DRAW 50 | MONSTERS

THE STEP-BY-STEP WAY TO DRAW

Creeps, Superheroes, Demons, Dragons, Nerds, Ghouls, Giants, Vampires, Zombies, and Other Scary Creatures

BOOKS IN THIS SERIES

- *Draw 50 Airplanes, Aircraft, and Spacecraft*
- *Draw 50 Aliens*
- *Draw 50 Animal 'Toons*
- *Draw 50 Animals*
- *Draw 50 Athletes*
- *Draw 50 Baby Animals*
- *Draw 50 Beasties*
- *Draw 50 Birds*
- *Draw 50 Boats, Ships, Trucks, and Trains*
- *Draw 50 Buildings and Other Structures*
- *Draw 50 Cars, Trucks, and Motorcycles*
- *Draw 50 Cats*
- *Draw 50 Creepy Crawlies*
- *Draw 50 Dinosaurs and Other Prehistoric Animals*
- *Draw 50 Dogs*
- *Draw 50 Endangered Animals*
- *Draw 50 Famous Cartoons*
- *Draw 50 Flowers, Trees, and Other Plants*
- *Draw 50 Horses*
- *Draw 50 Magical Creatures*
- *Draw 50 Monsters*
- *Draw 50 People*
- *Draw 50 Princesses*
- *Draw 50 Sharks, Whales, and Other Sea Creatures*
- *Draw 50 Vehicles*
- *Draw the Draw 50 Way*

DRAW 50

MONSTERS

THE STEP-BY-STEP WAY TO DRAW
Creeps, Superheroes, Demons, Dragons, Nerds, Ghouls, Giants, Vampires, Zombies, and Other Scary Creatures

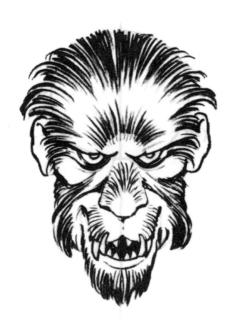

LEE J. AMES

WATSON-GUPTILL PUBLICATIONS
Berkeley

Published in the United States by Watson-Guptill Publications, an imprint of the Crown Publishing Group, a division of Random House LLC, a Penguin Random House Company, New York.
www.crownpublishing.com
www.watsonguptill.com

WATSON-GUPTILL and the WG and Horse designs are registered trademarks of Random House LLC.

Originally published in hardcover in the United States by Doubleday, a division of Random House LLC, New York, in 1983.

The Library of Congress has cataloged the earlier edition as follows:

Ames, Lee J.
 Draw 50 monsters, creeps, superheroes, demons, nerds, dirts, ghouls, giants, vampires, zombies, and other curiosa.../ Lee J. Ames. – 1st revised ed.

 p. cm.
1. Monsters in art—Juvenile literature. 2. Animals, Mythical, in art—Juvenile literature. 3. Drawing—Technique—Juvenile literature.
[1. Monsters in art. 2. Drawing—Technique] I. Title. II. Title: Draw fifty monsters, creeps, superheroes, demons, dragons, nerds, dirts, ghouls, giants, vampires, zombies, and other curiosa...

NC825.M6A47 1983
741.2/4
 80003006

ISBN 978-0-8230-8584-2
eISBN 978-0-307-79501-4

Printed in the United States of America

10 9 8 7 6 5

2014 Watson-Guptill Edition

3 9547 00433 5993

To the jokesters down at Whaler's
and to Walter, loved so well...

Thanks, Holly!
Thanks, Tamara!
Thanks to Doug Bergstreser for the idea.

To the Reader

A wild and wacky collection of monsters and other fantastic creatures awaits you in this book, and by following simple, step-by-step instructions, you can draw each and every one of them, from the Bride of Frankenstein to Sasquatch.

Start by gathering your equipment. You will need paper, medium and soft pencils, and a kneaded eraser (available at art supply stores). You may also wish to have on hand India ink, a fine brush or pen, and a compass.

Next, pick the creature of your choice—you need not start with the first illustration. As you begin, keep in mind that the first few steps—the foundation of the drawing—are the most important. The whole picture will be spoiled if they are not right. So, follow these steps *very carefully,* keeping the lines as light as possible. So that they can be clearly seen, these lines are shown darker in this book than you should draw them. You can lighten your marks by gently pressing them with the kneaded eraser.

Make sure step one is accurate before you go on to step two. To check your own accuracy, hold the work up to a mirror after a few steps. By reversing the image, the mirror gives you a new view of the drawing. If you haven't done it quite right, you may notice that your drawing is out of proportion or off to one side.

You can reinforce the drawing by going over the completed final step with India ink and a fine brush or pen. When the ink has dried, gently remove the pencil lines with the kneaded eraser.

Don't get discouraged if, at first, you find it difficult to duplicate the shapes pictured. Just keep at it, and in no time you'll be able to make the pencil go just where you wish. Drawing, like any other skill, requires patience, practice, and perseverance.

Remember, this book presents only one method of drawing. In a most enjoyable way, it will help you develop a certain skill and control. But there are many other ways of drawing to which you can apply this skill, and the more of them you explore, the more interesting your drawings will be.

Lee J. Ames

To the Parent or Teacher

The ability to make a credible, amusing, or attractive drawing never fails to fill a child with pride and a sense of accomplishment. This in itself provides the motivation for a child to cultivate that ability further.

There are diverse approaches to developing the art of drawing. Some contemporary ways stress freedom of expression, experimentation, and self-evaluation of competence and growth. More traditional is the "follow me, step-by-step" method which teaches through mimicry. Each approach has its own value, and one need not exclude the other.

This book teaches a way of drawing based on the traditional method. It will give young people the opportunity to produce skillful, funny drawings of monsters and other creatures by following simple instructions. After completing a number of such drawings, the child will almost surely have picked up some of the fundamentals of handling and controlling the materials and of creating believable forms, and a sense of the discipline needed to master the art of drawing. From here, the child can continue with other books in the DRAW 50 series — and at the same time, explore other methods of drawing which he or she will now be better equipped to deal with.

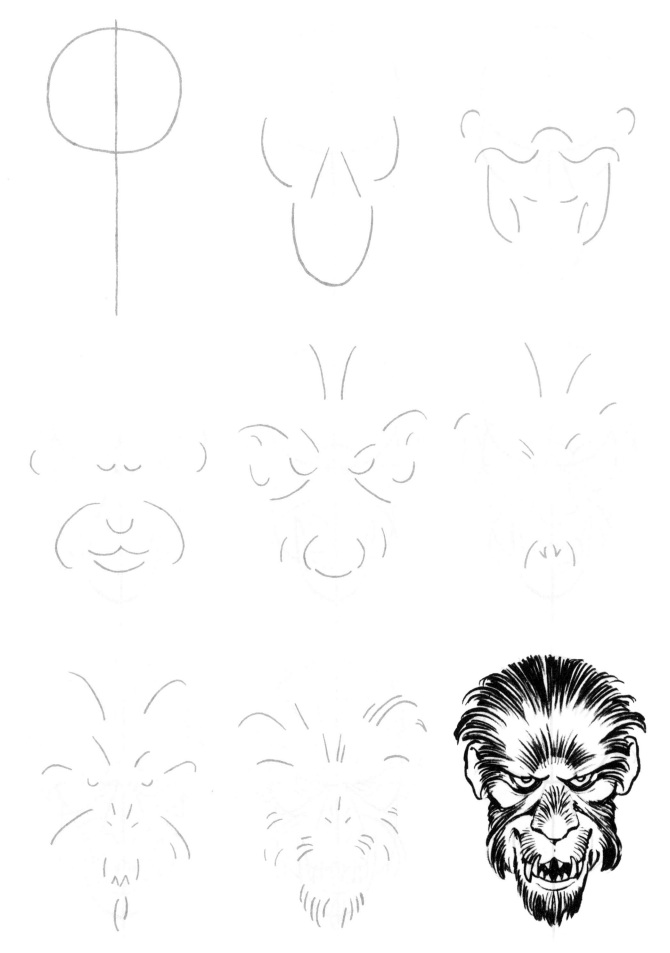

Werner Werewolf

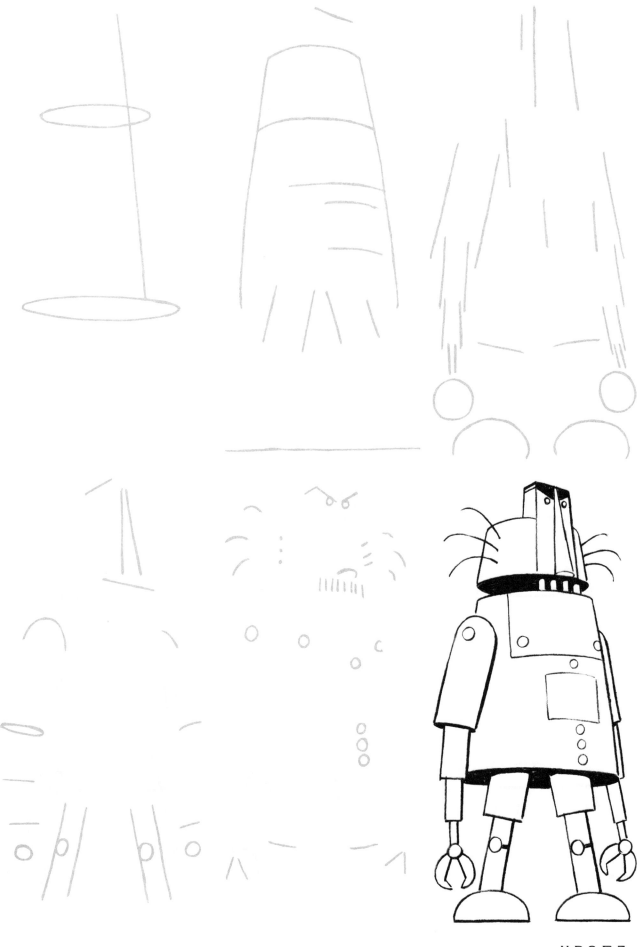

UR2EZ

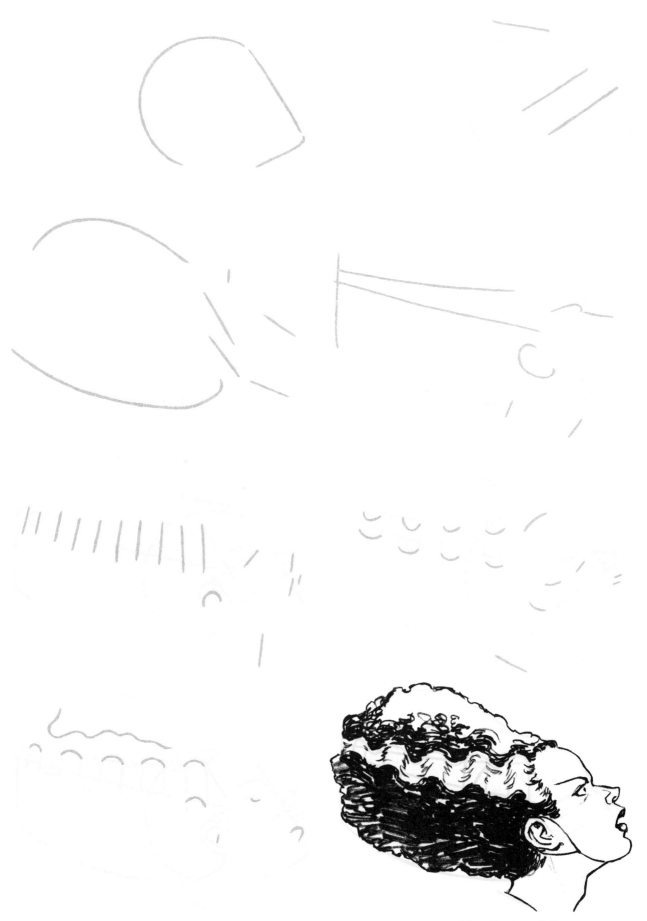

The Bride of Frankenstein

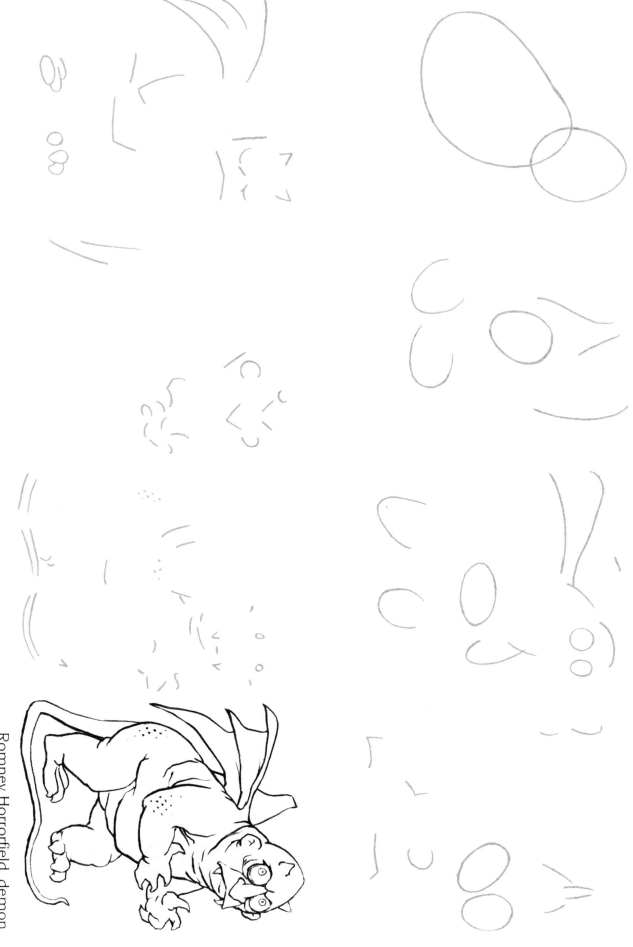

Romney Horrorfield, demon

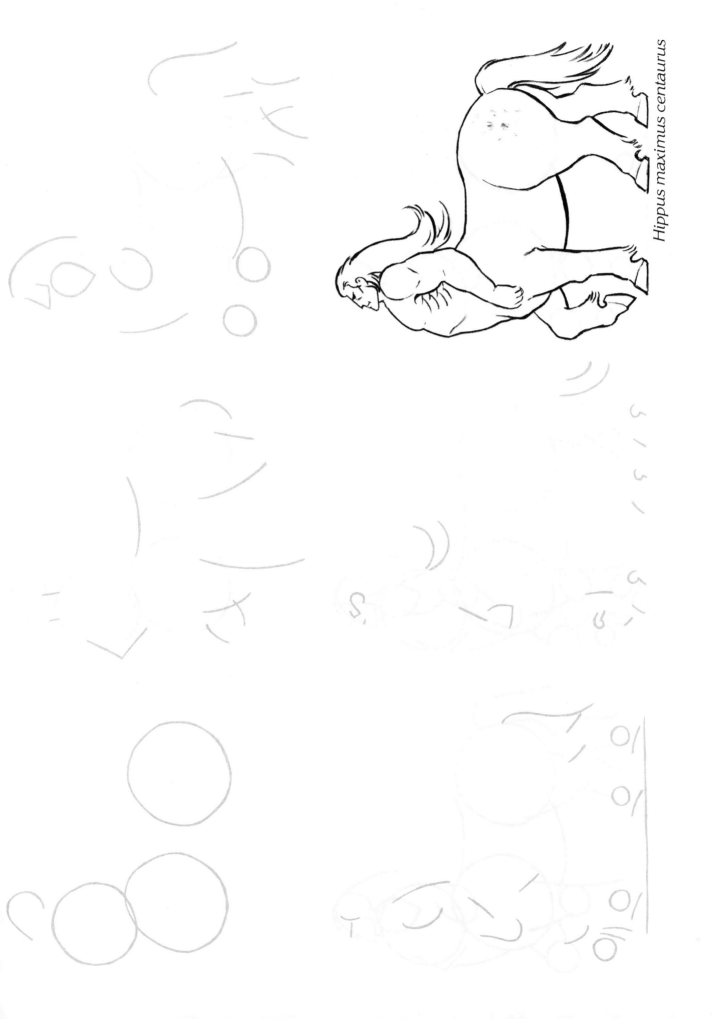

Hippus maximus centaurus

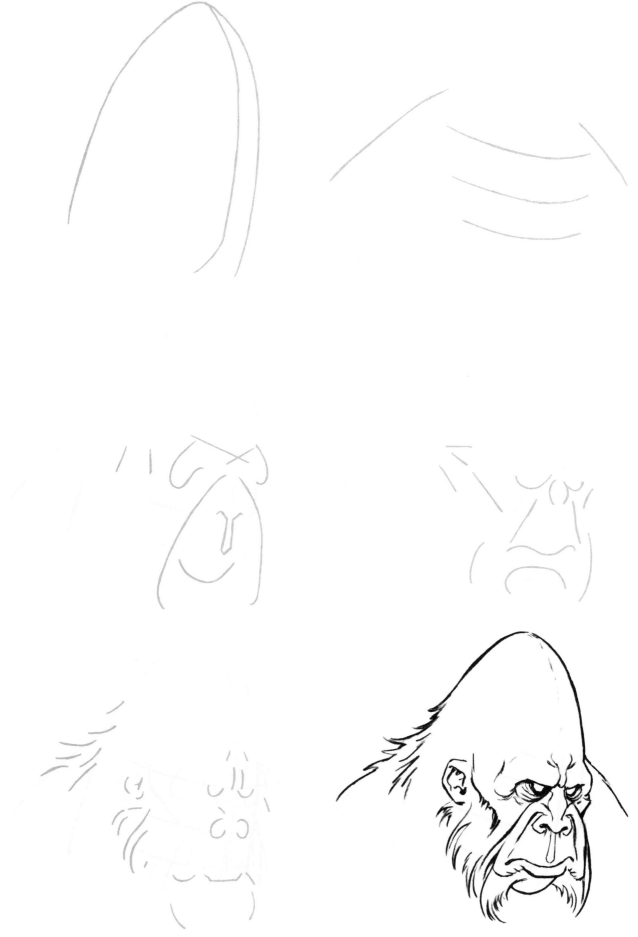

Sasquatch

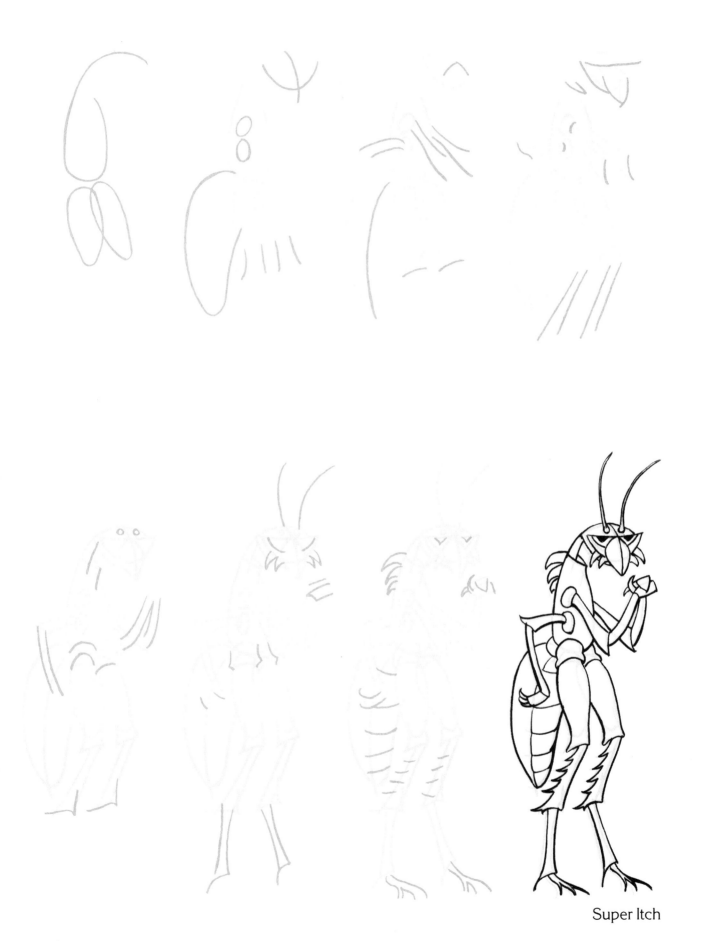

Super Itch

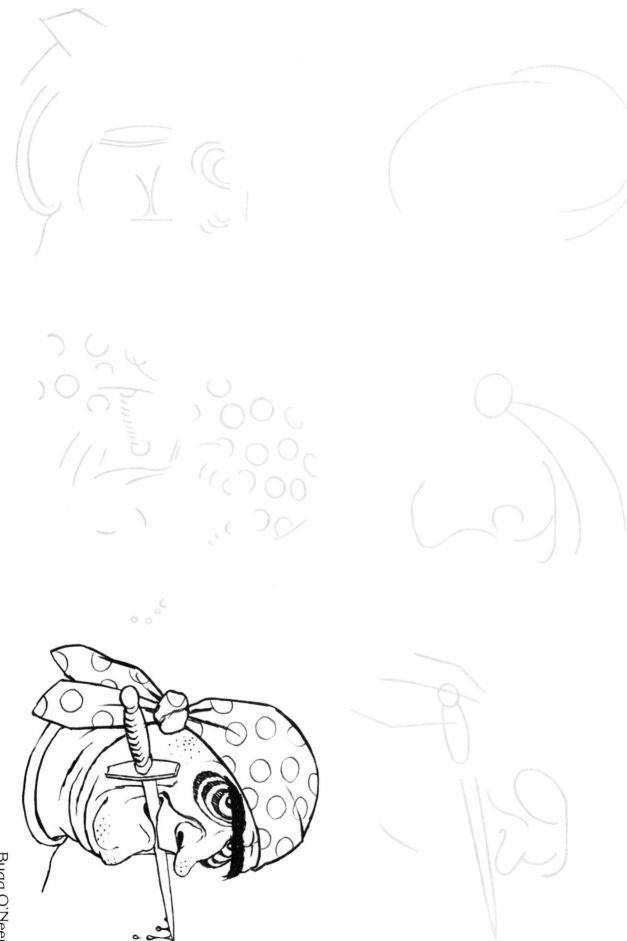

Bugg O'Neer

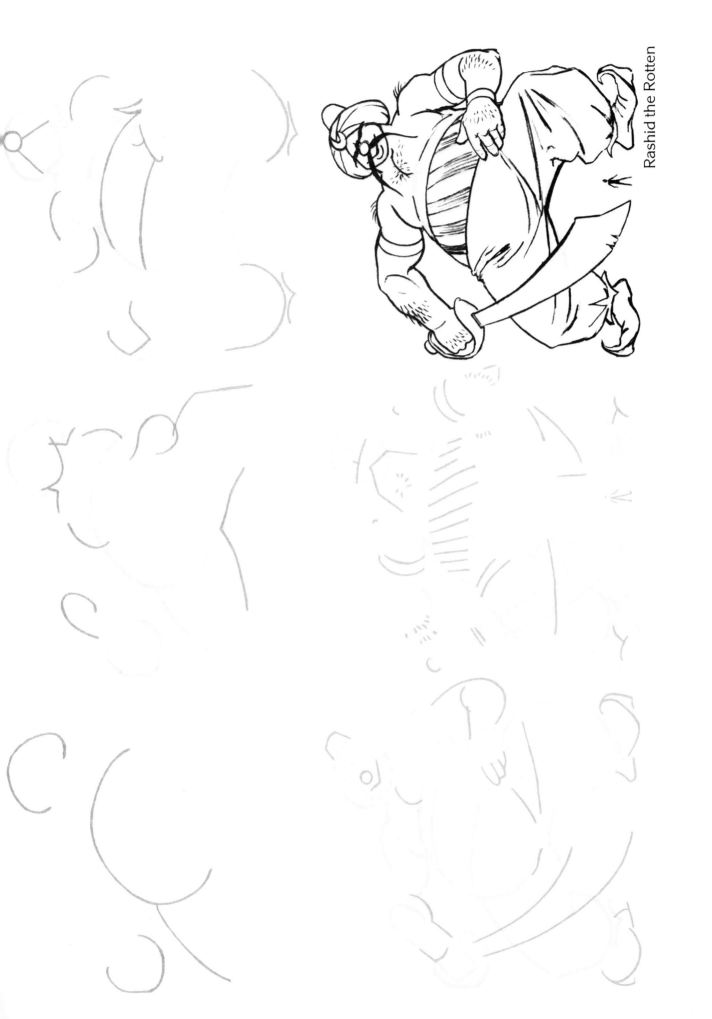

Rashid the Rotten

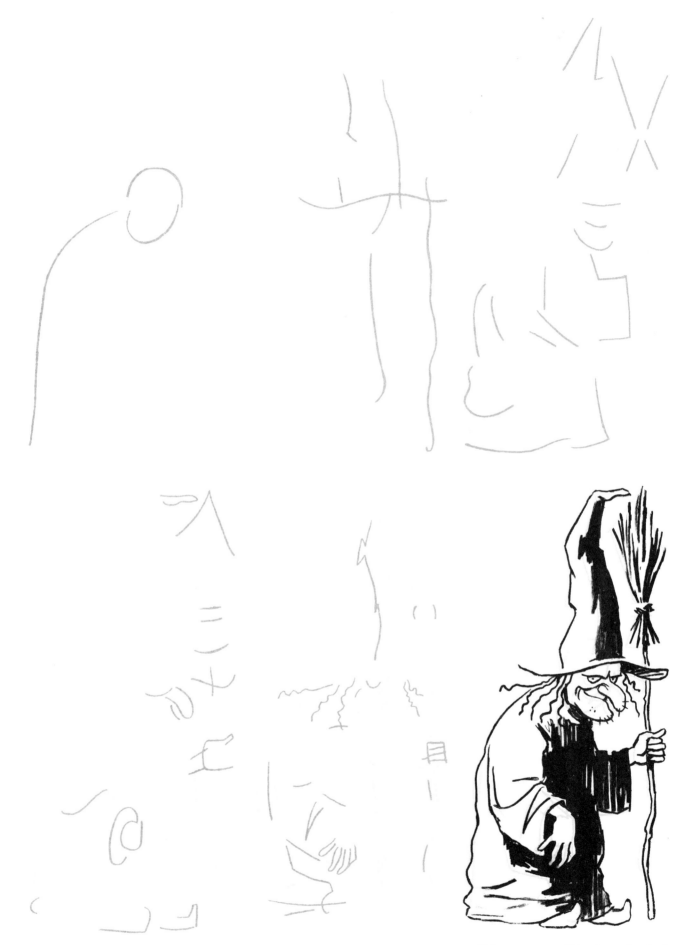

Wynsomme Warthead, witch

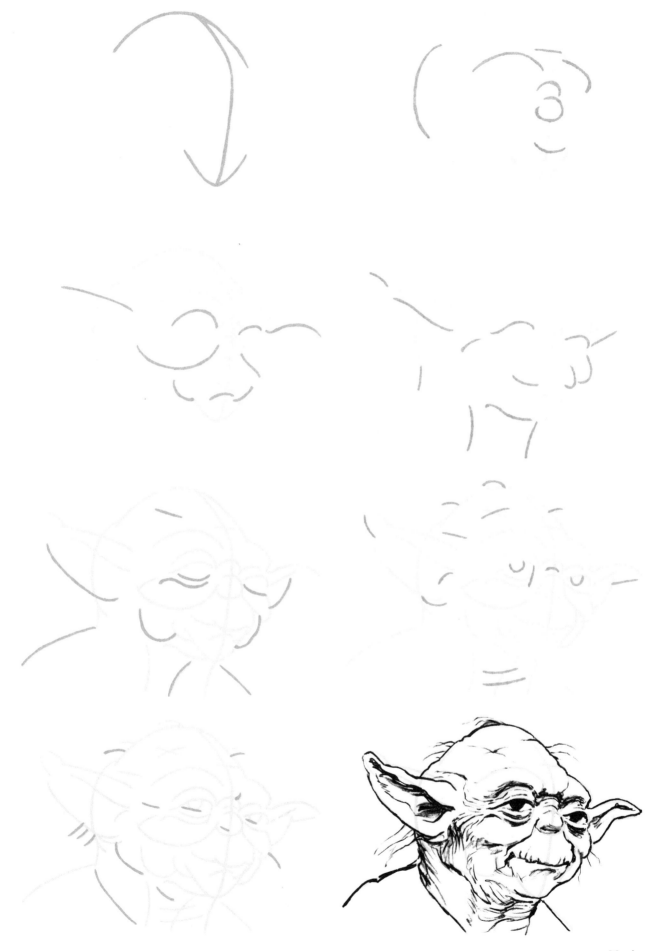

Yoda

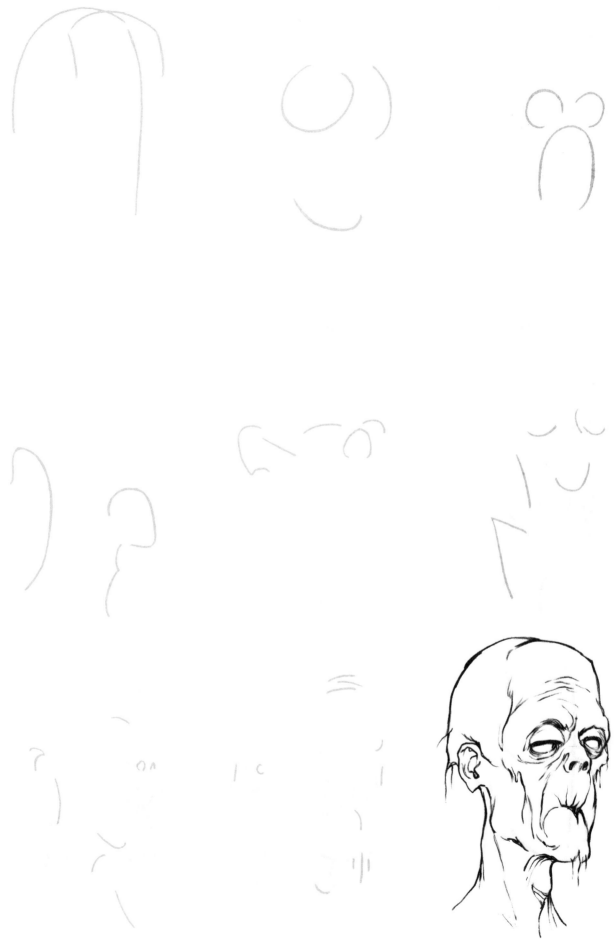

Reeko Mortis, zombie

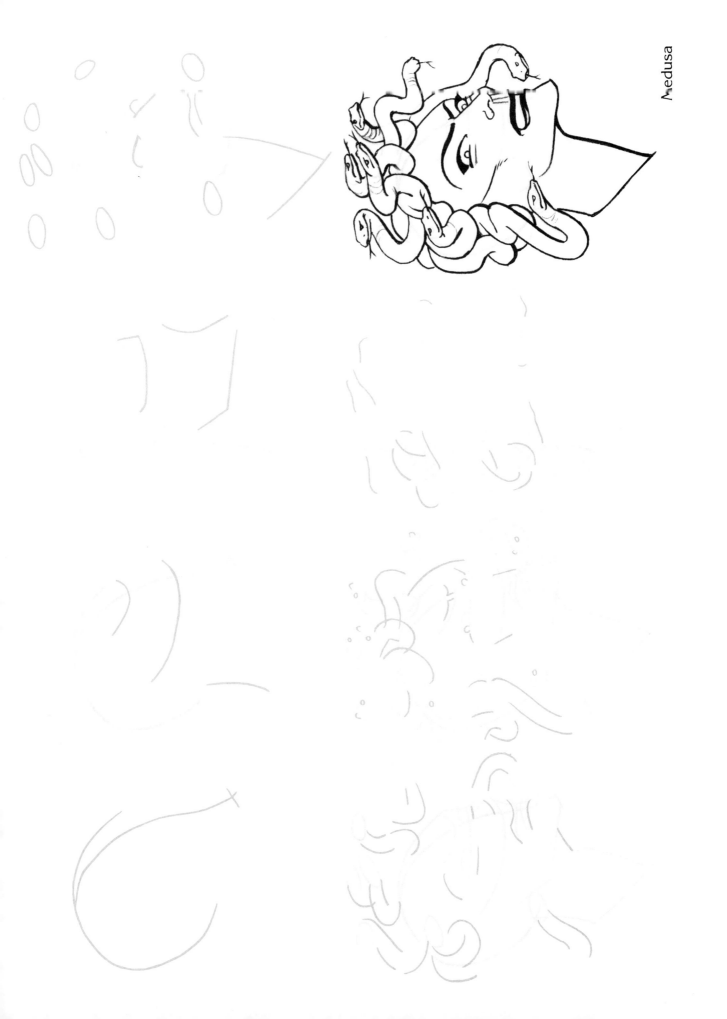

Medusa

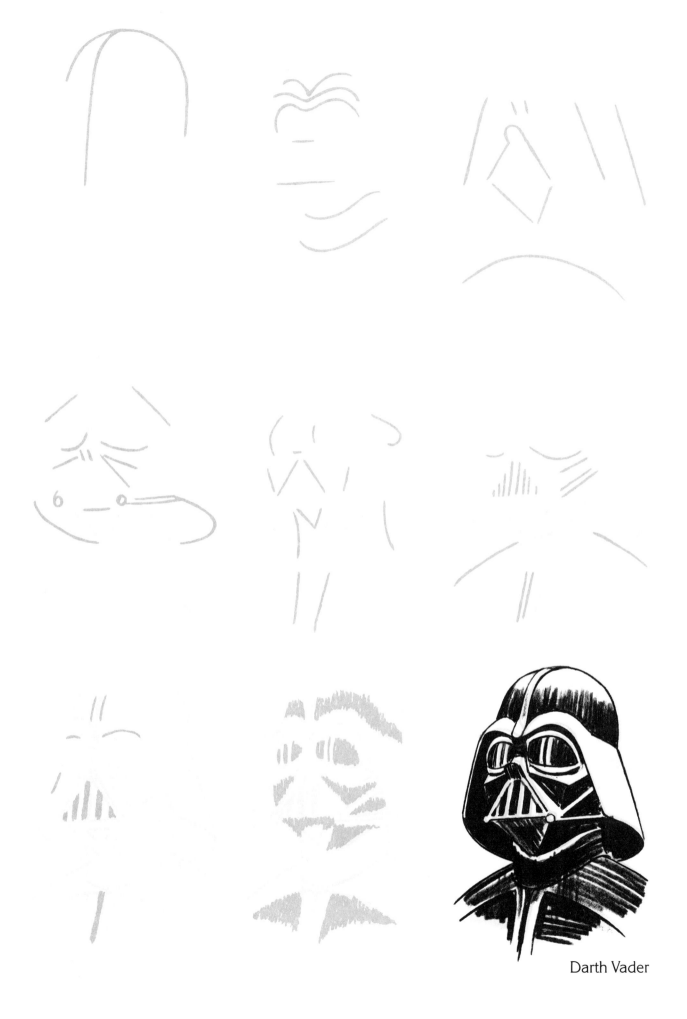

Darth Vader

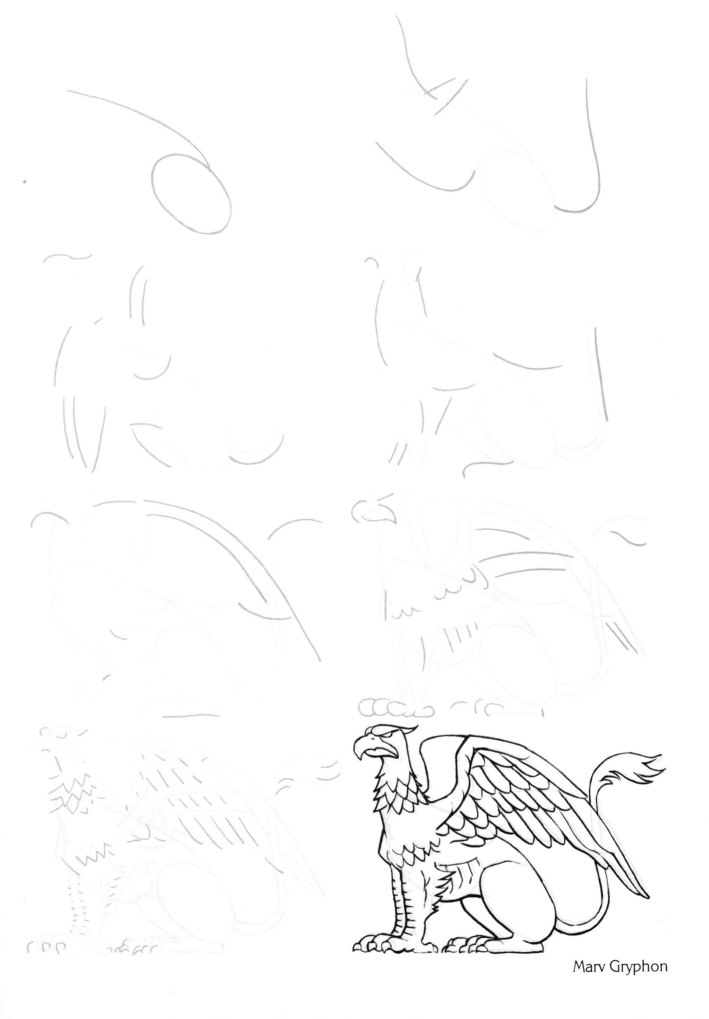

Marv Gryphon

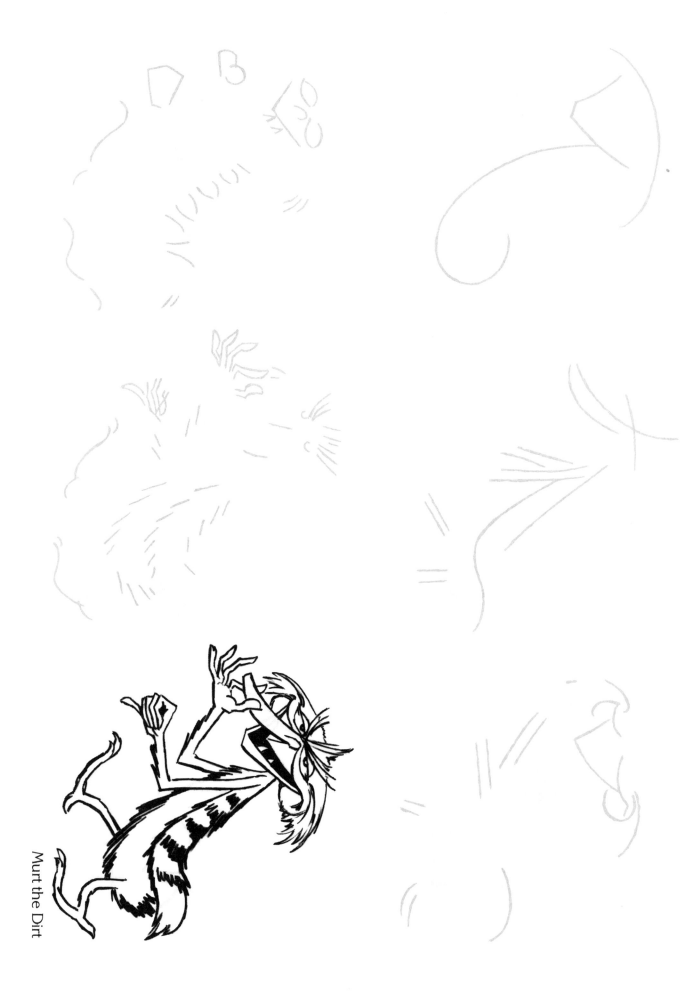

Murt the Dirt

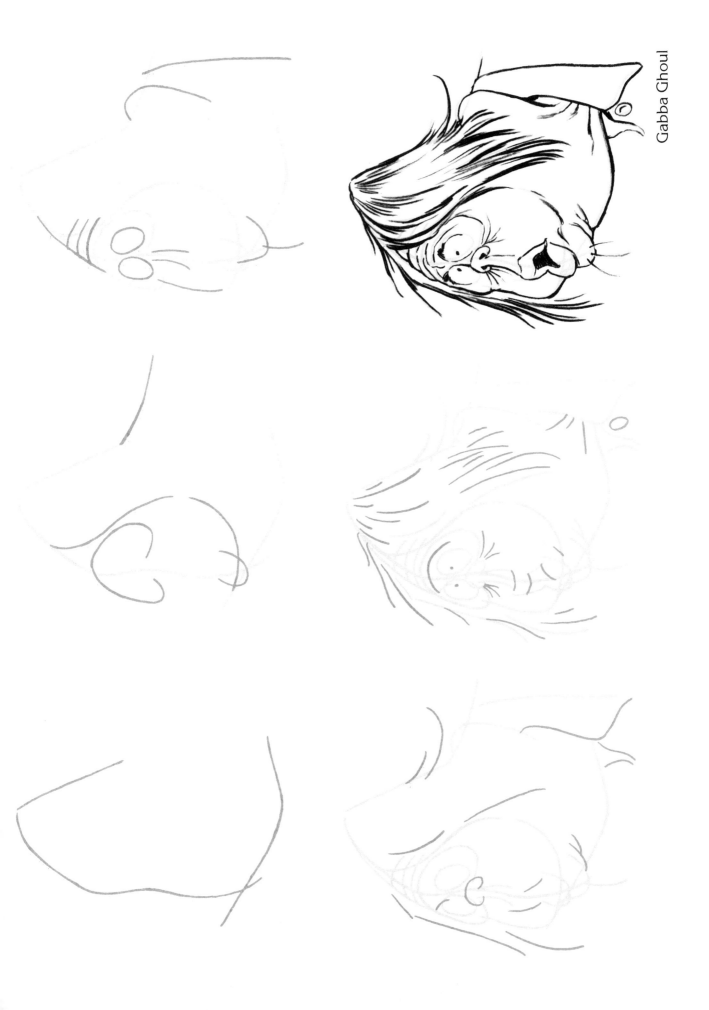

Gabba Ghoul

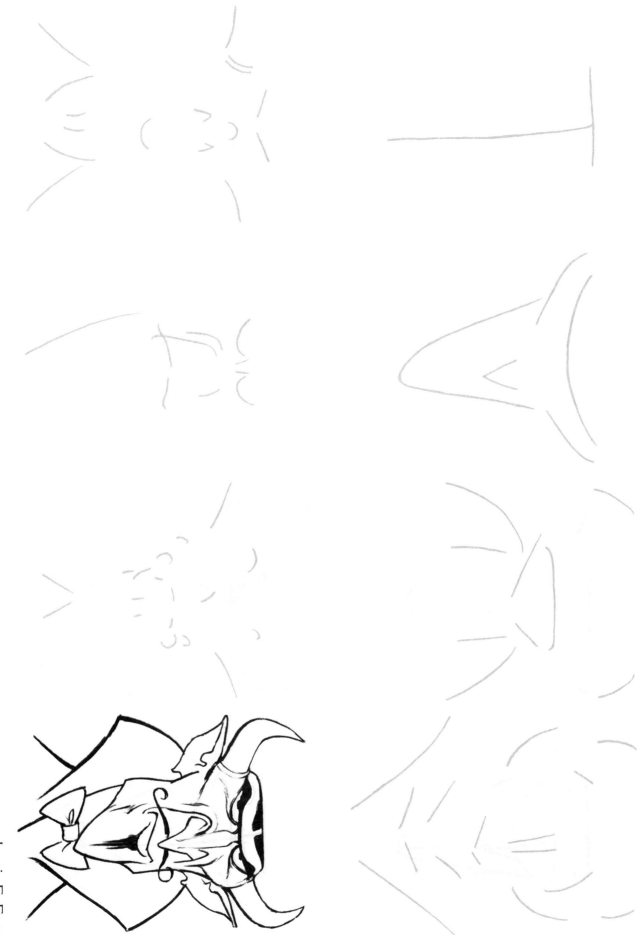

Lewis E. Furr

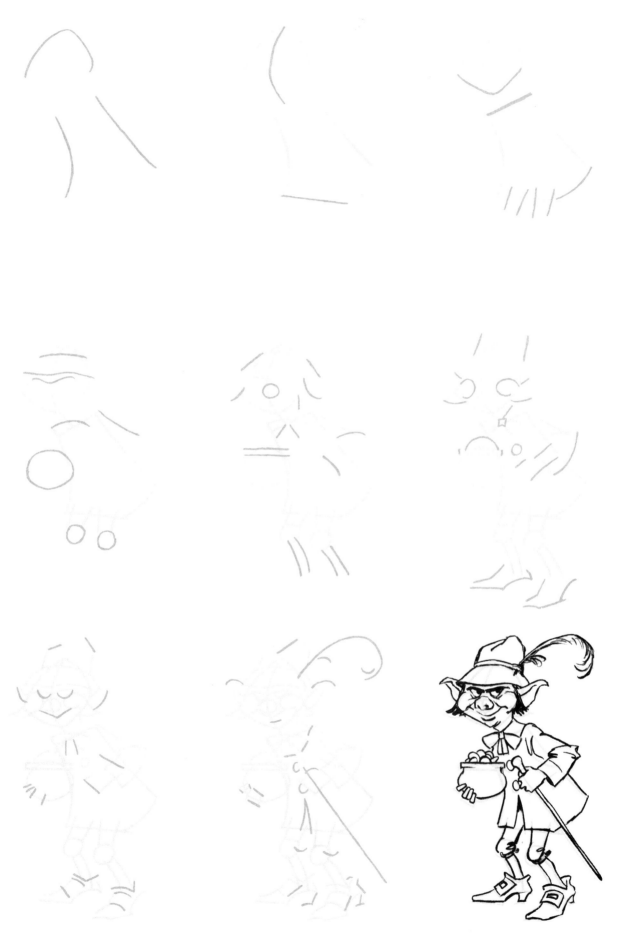

Wee Seamus Kildare, leprechaun

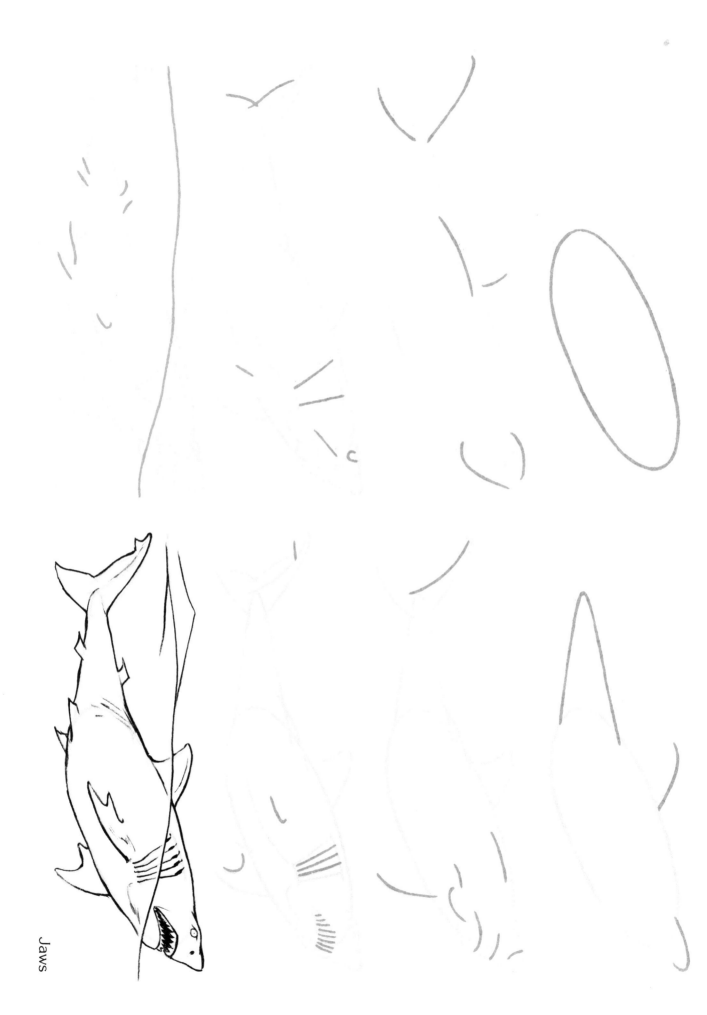

Jaws

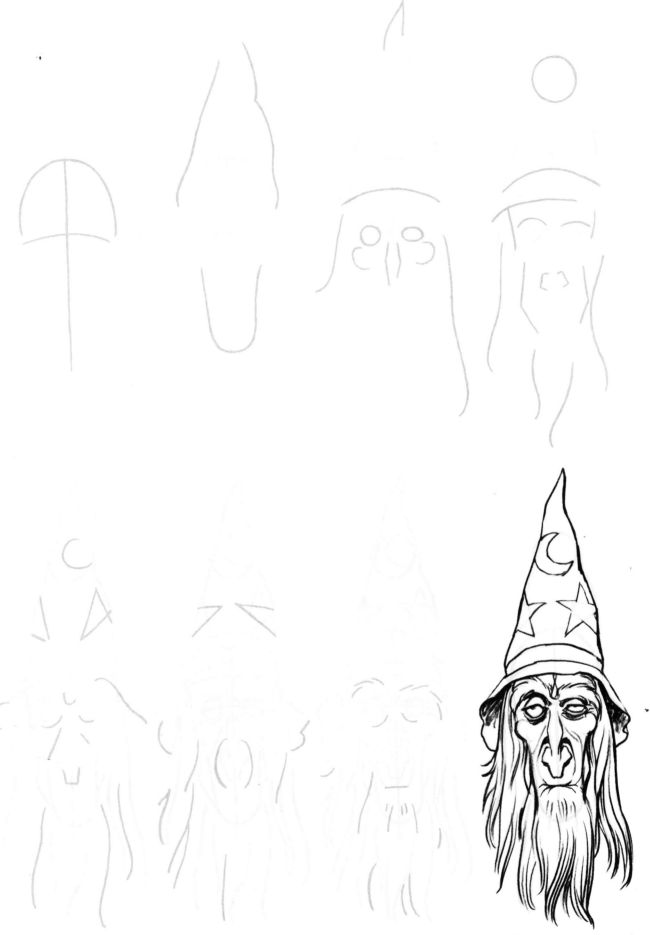

Egeni Chillingstone, warlock

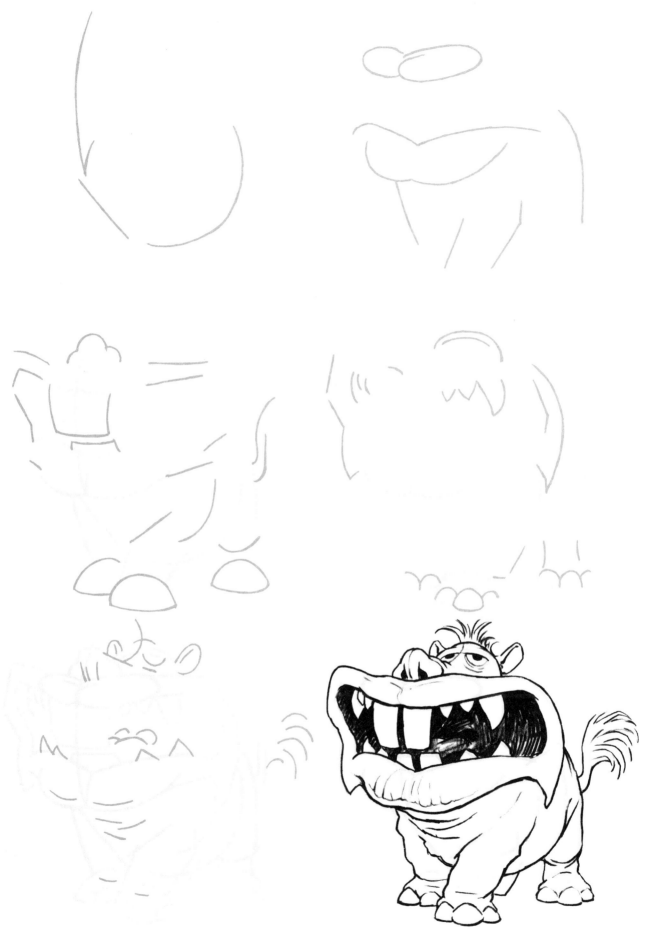

Ezobite mouth creach

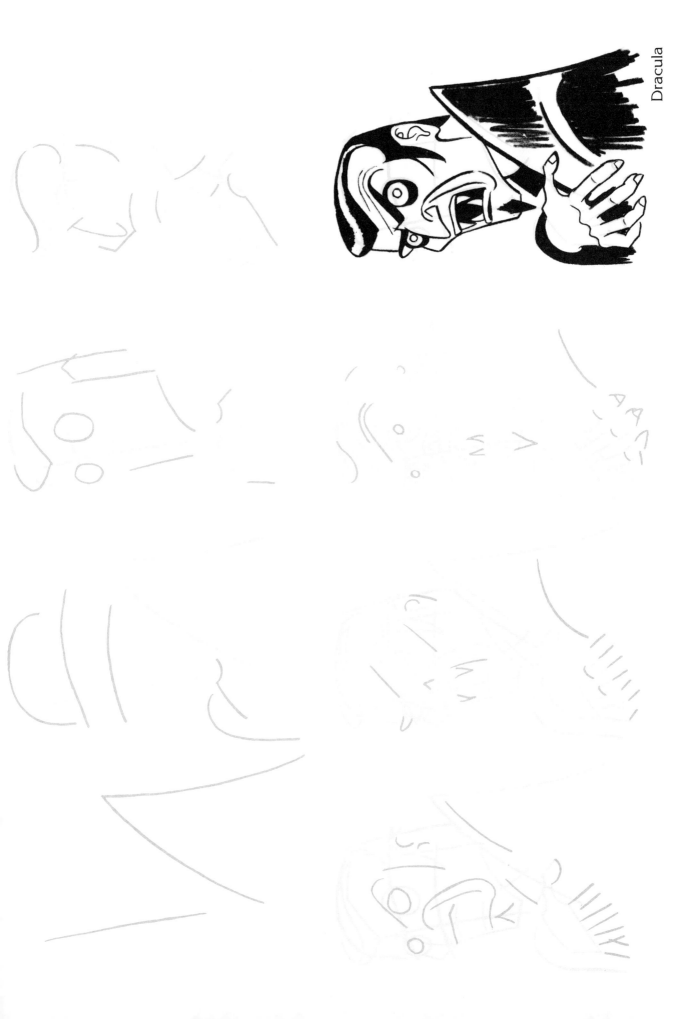

Dracula

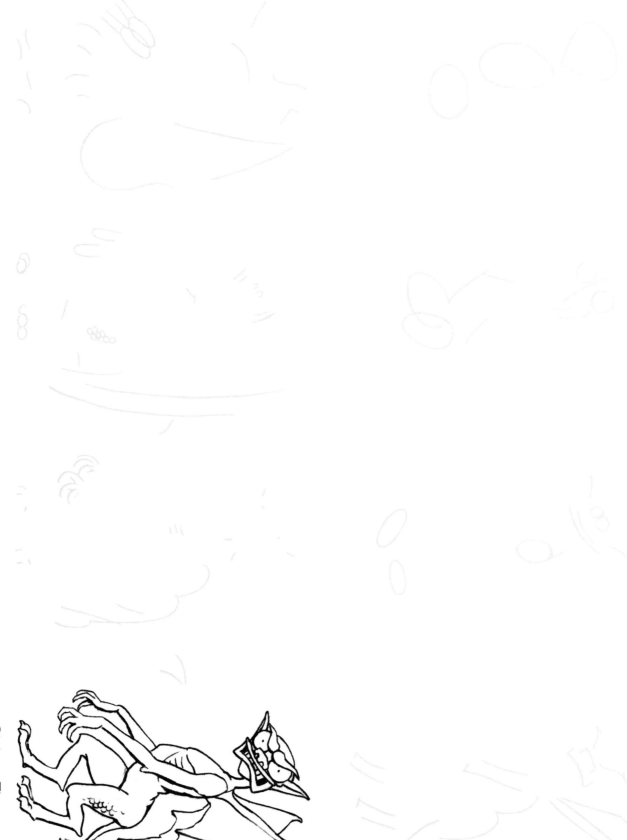

Sinister Finster, dark demon

Feodor the Dwarf

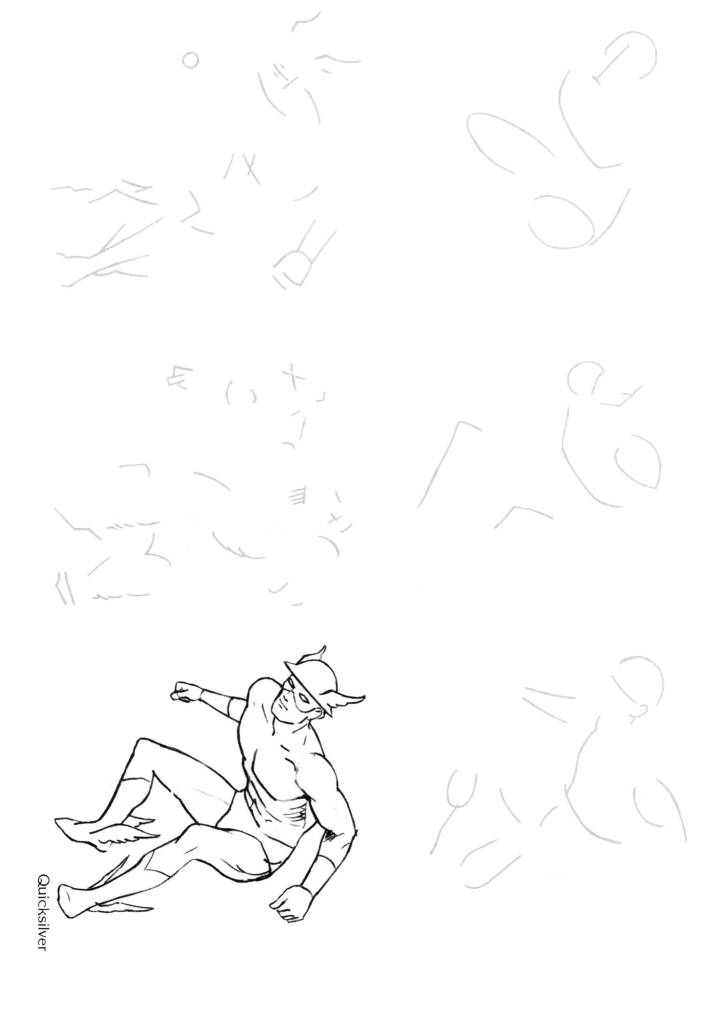

Quicksilver

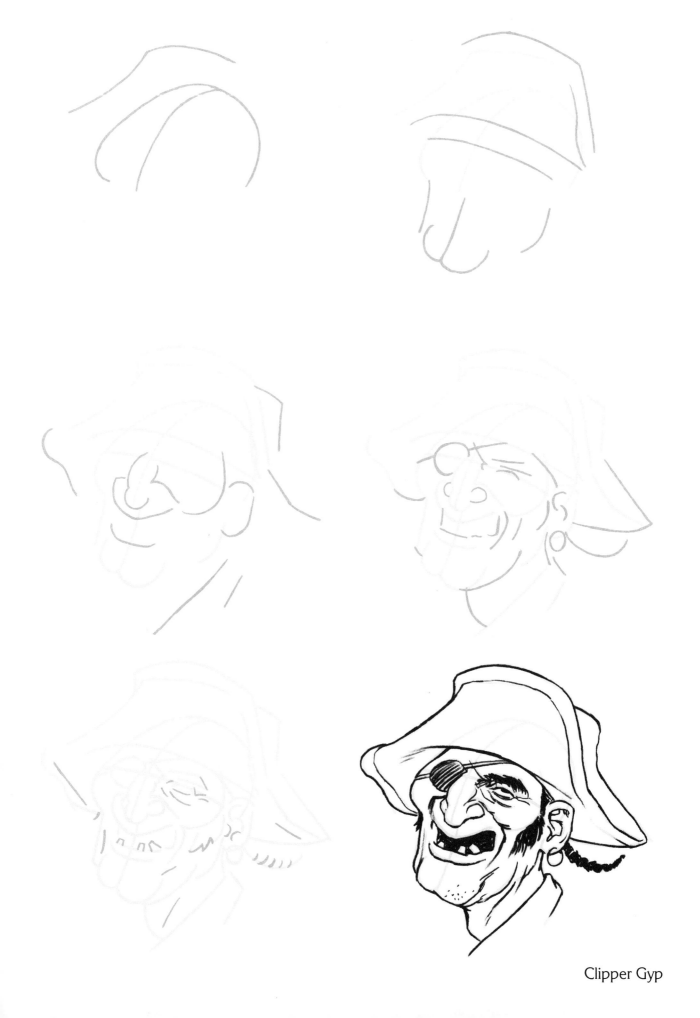

Clipper Gyp

Demon from the Second Planet Circling Sirius

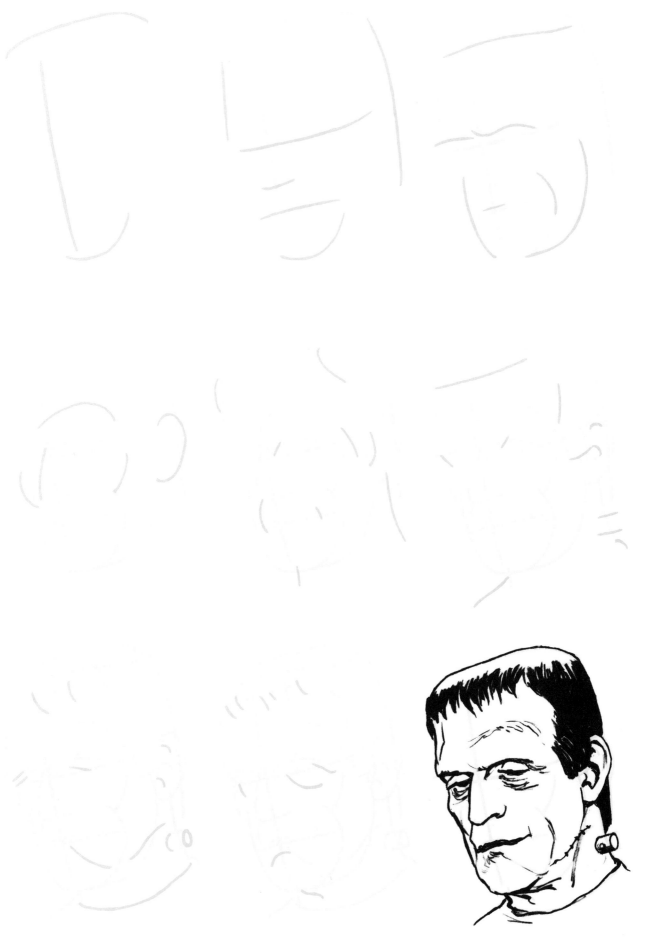

Frankenstein's Monster

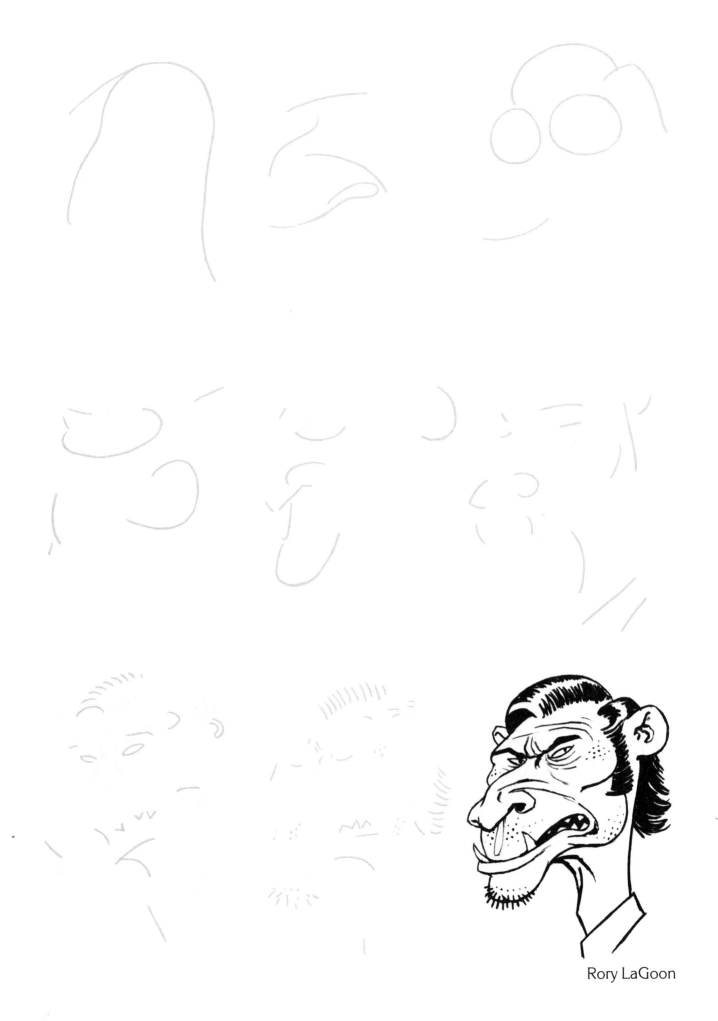

Rory LaGoon

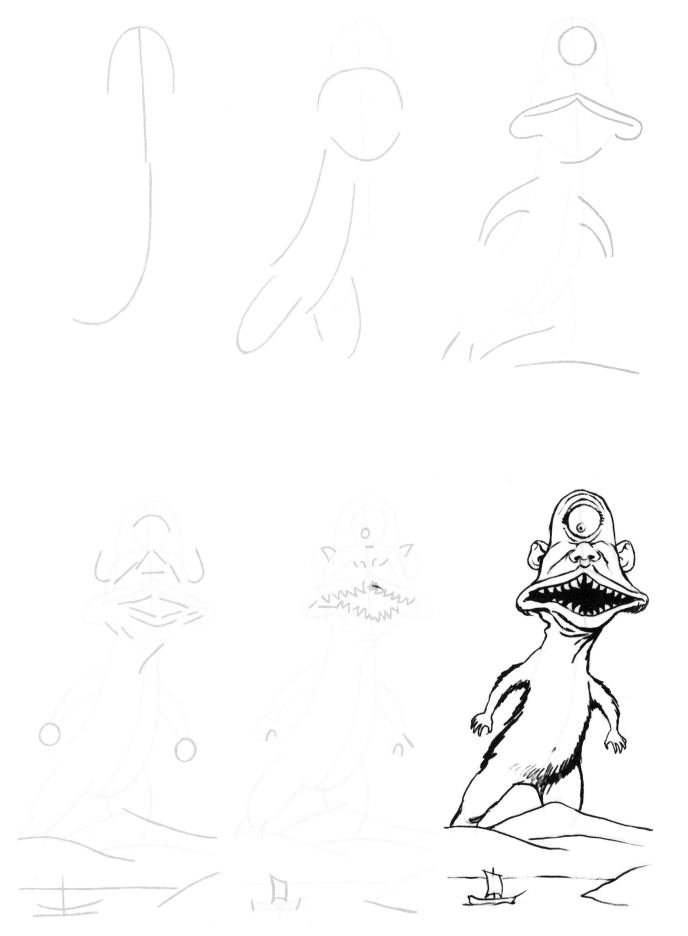

Cyclops

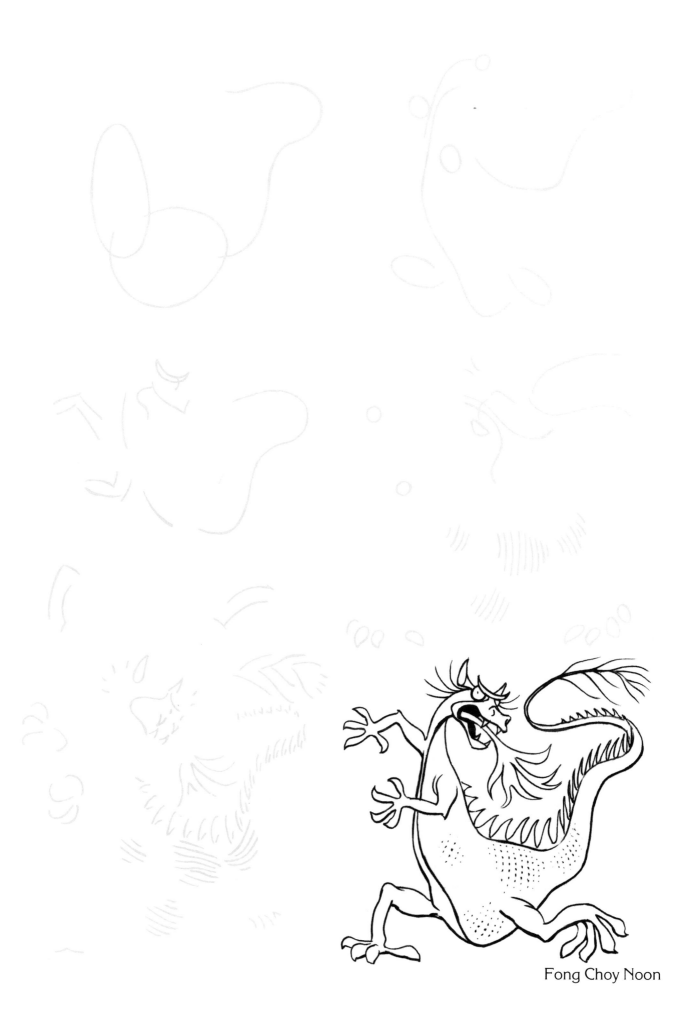

Fong Choy Noon

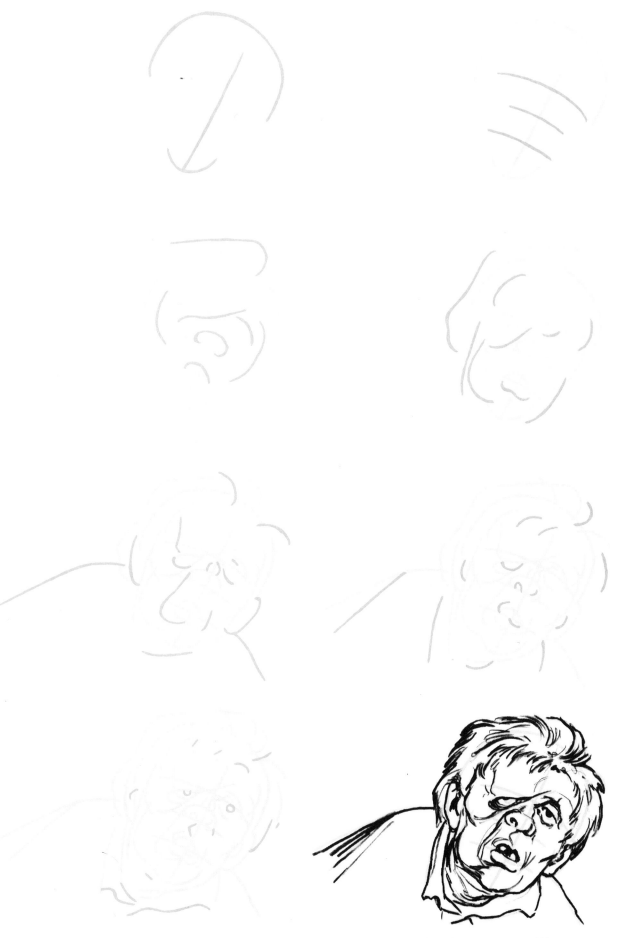

The Hunchback of Notre Dame

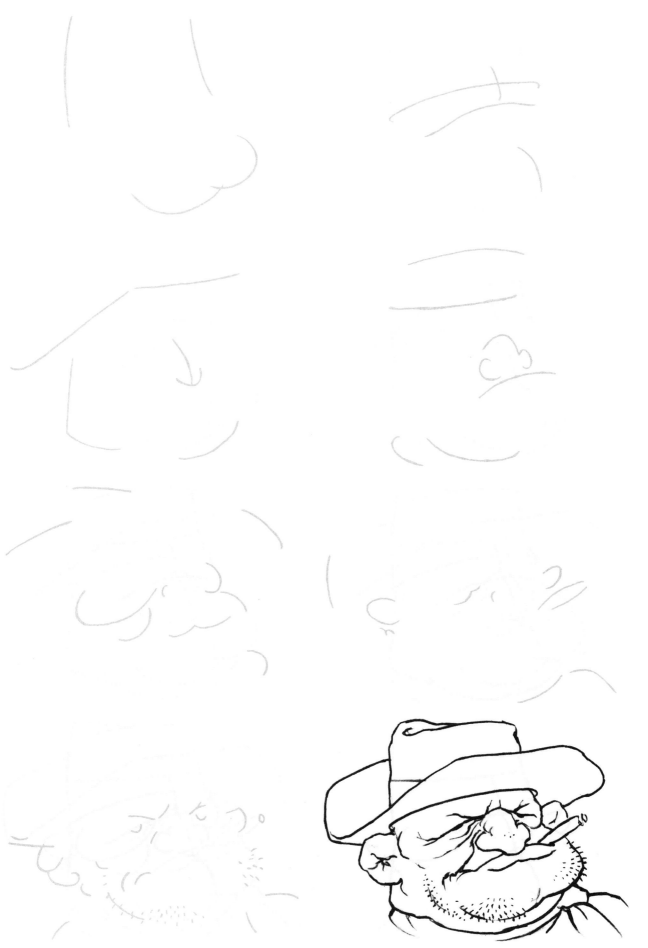

Lousy Larrabee

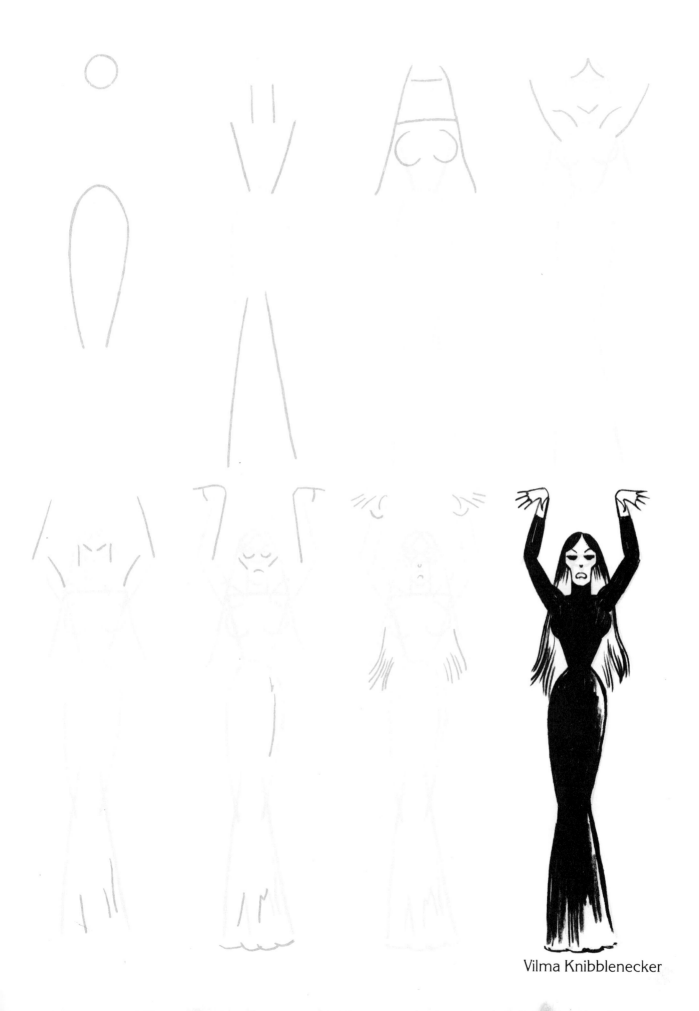

Vilma Knibblenecker

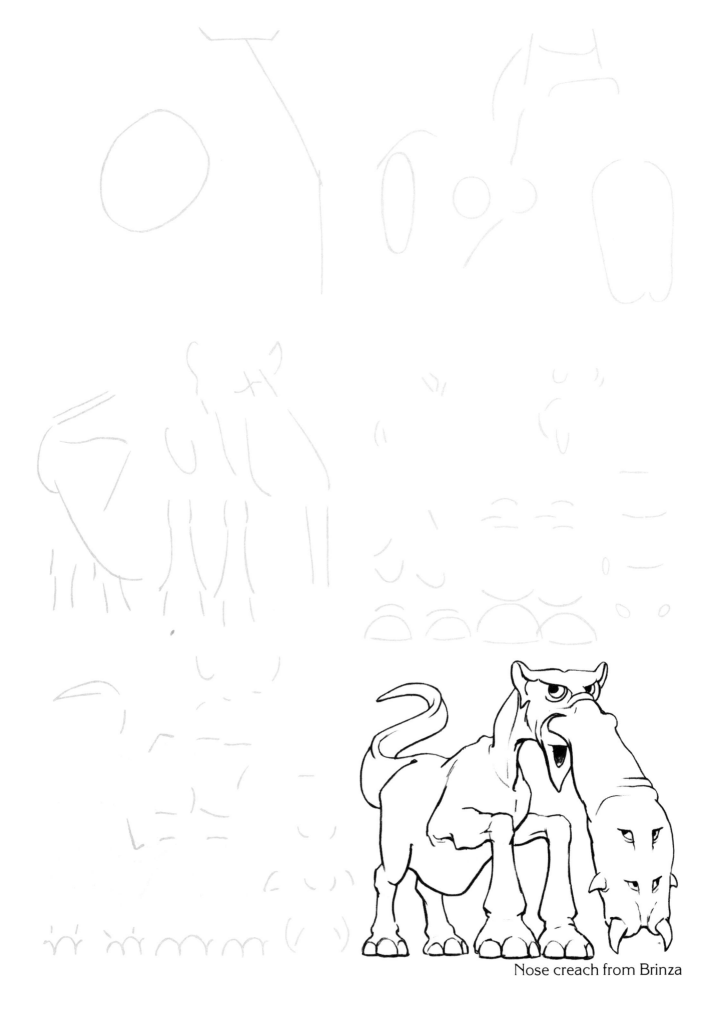

Nose creach from Brinza

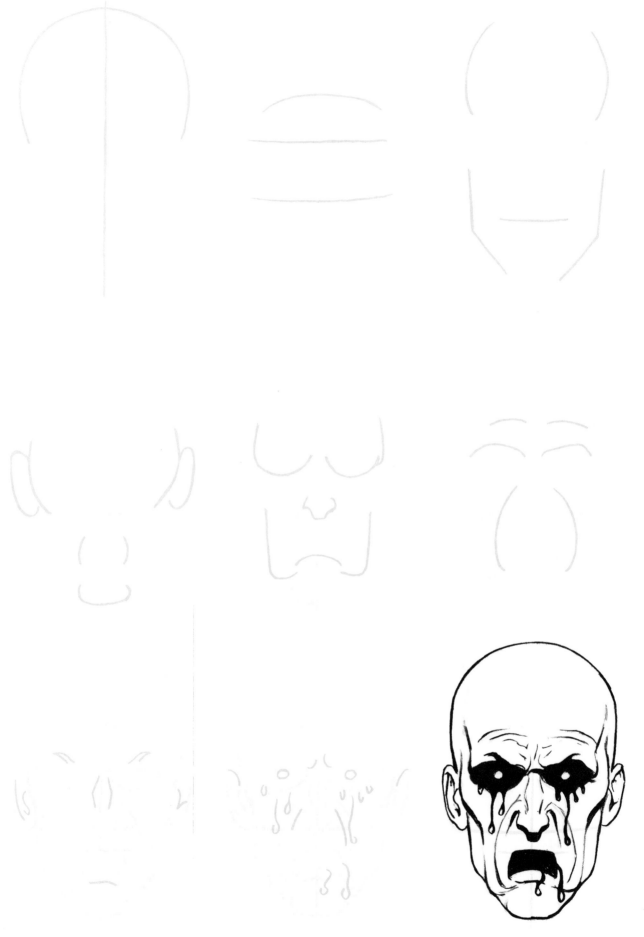

Bluddin Gaur, zombie

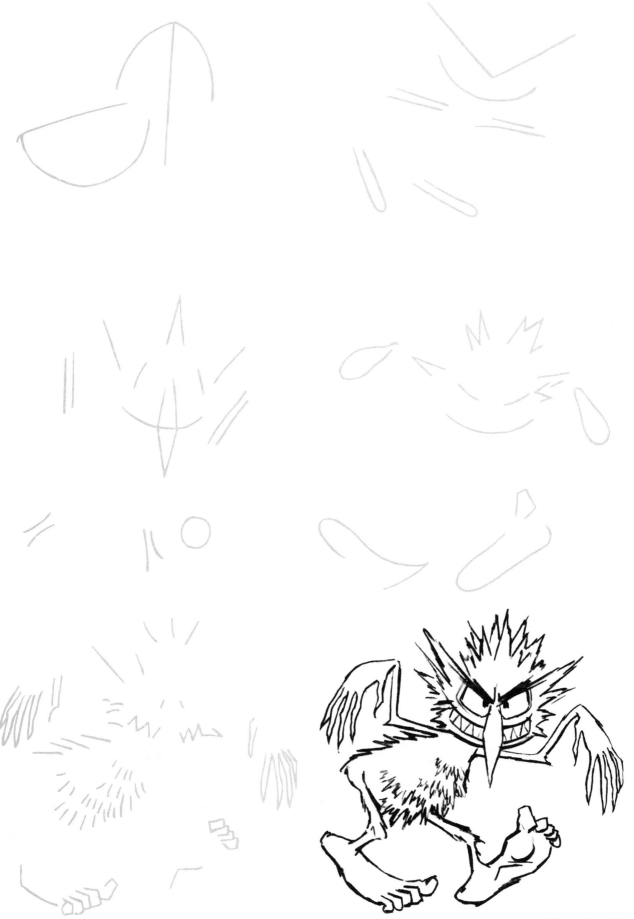

Burt the Dirt

Hercules

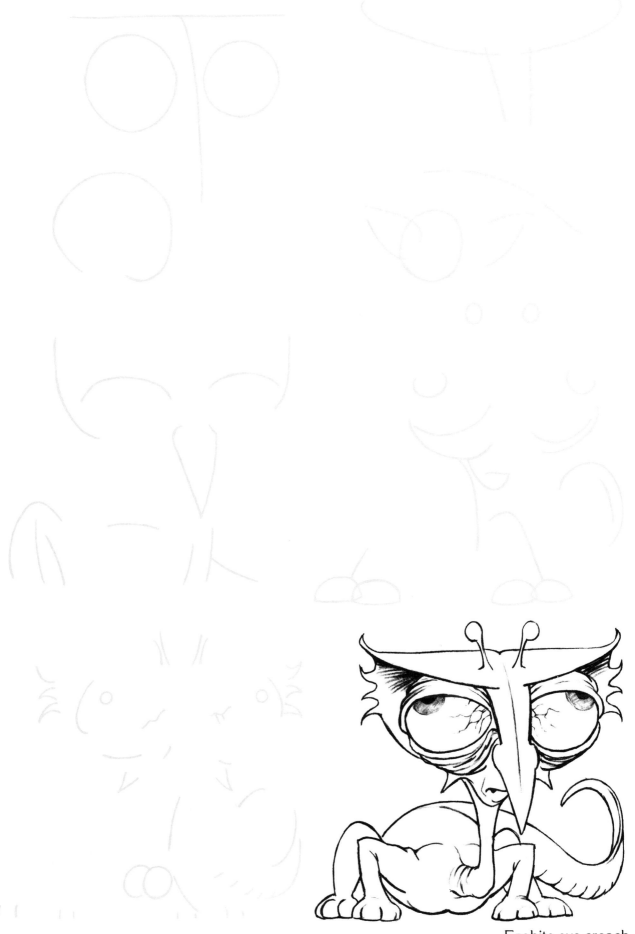

Ezobite eye creach

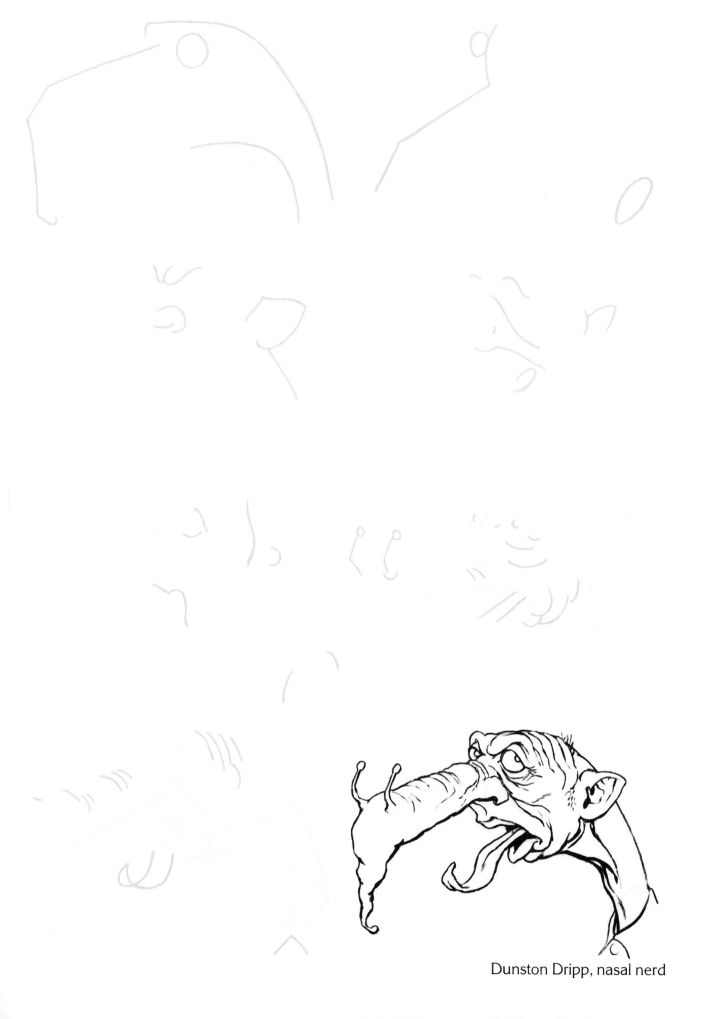

Dunston Dripp, nasal nerd

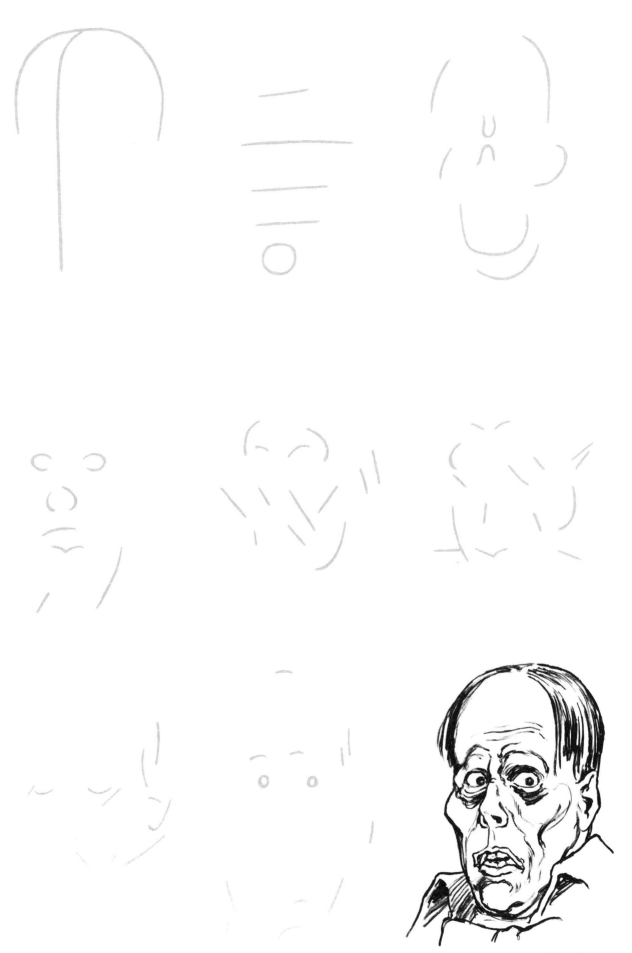

The Phantom of the Opera

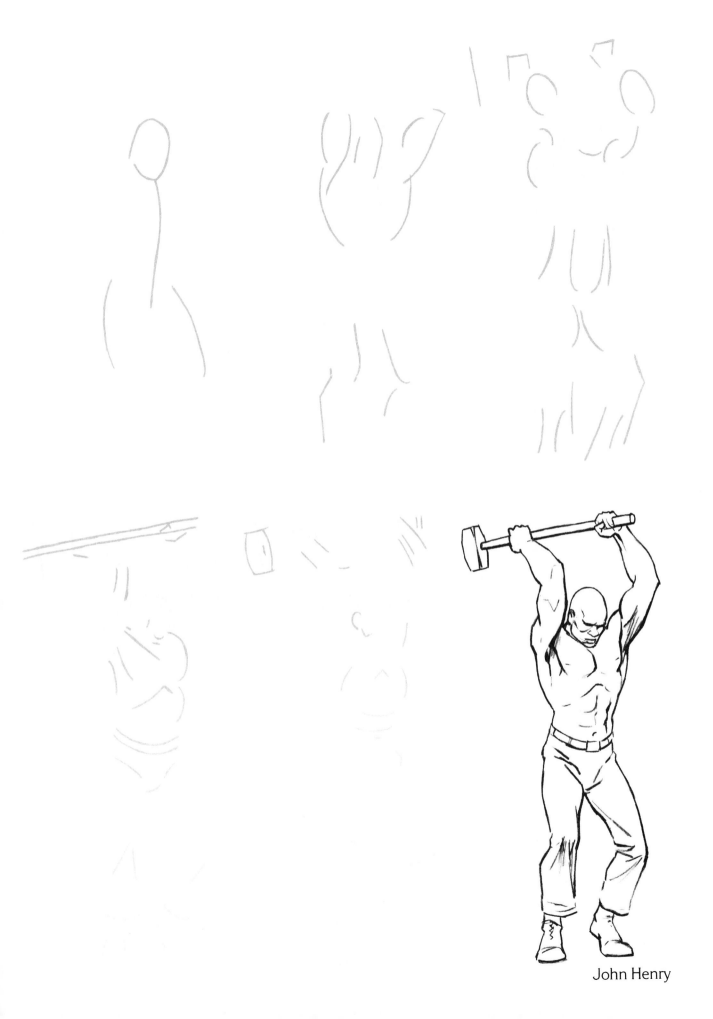

John Henry

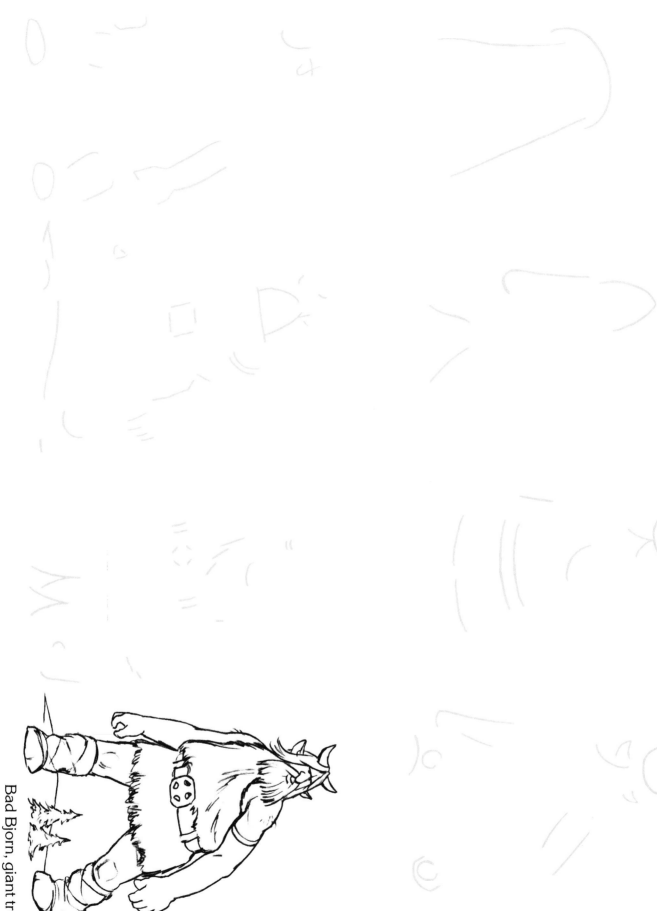

Bad Bjorn, giant troll

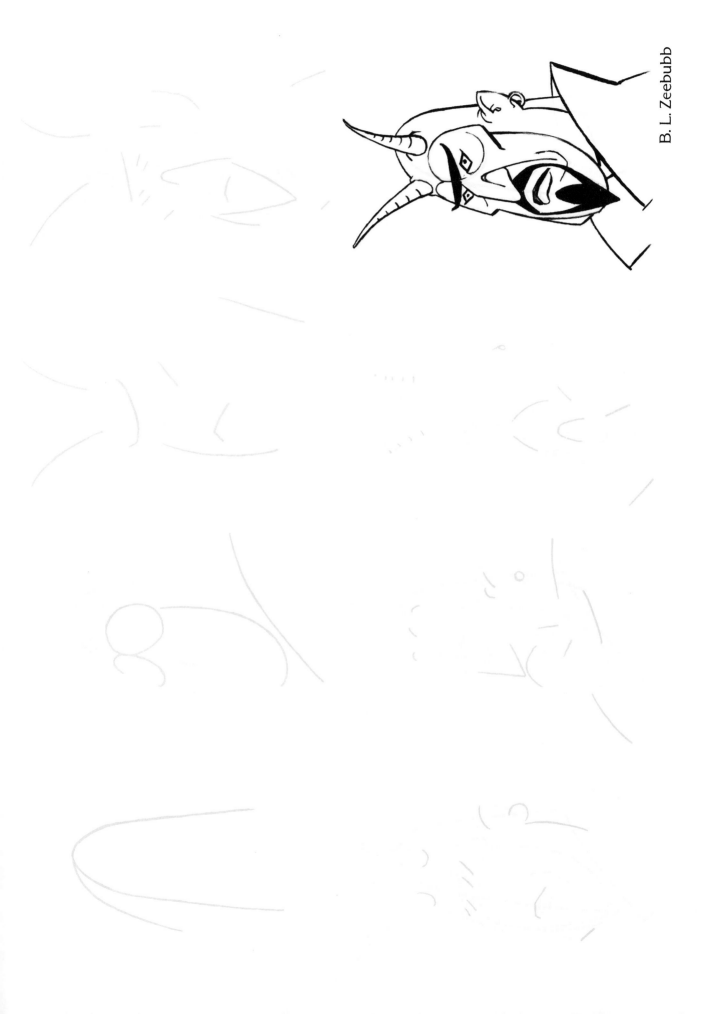

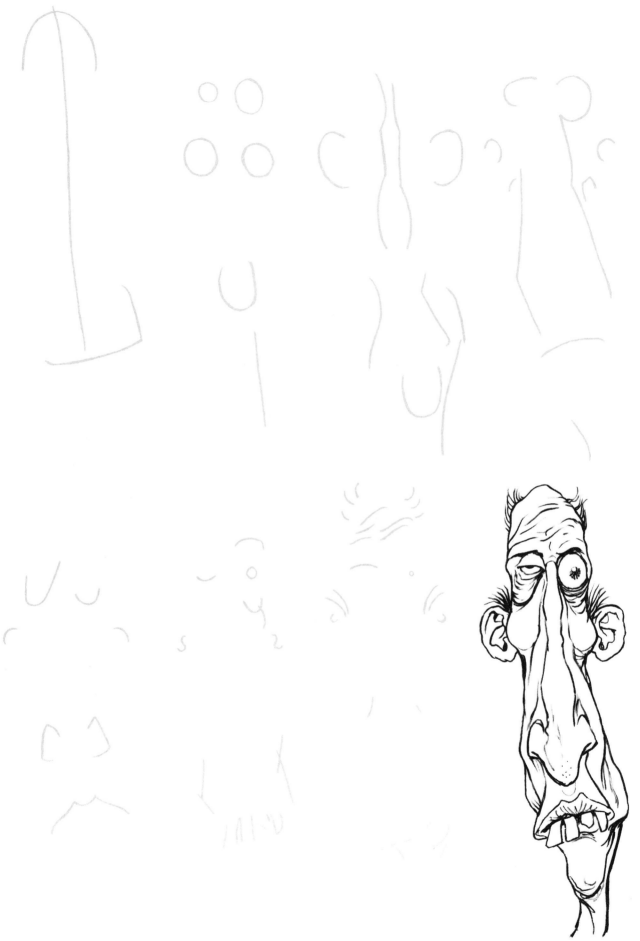

Uriah Creep

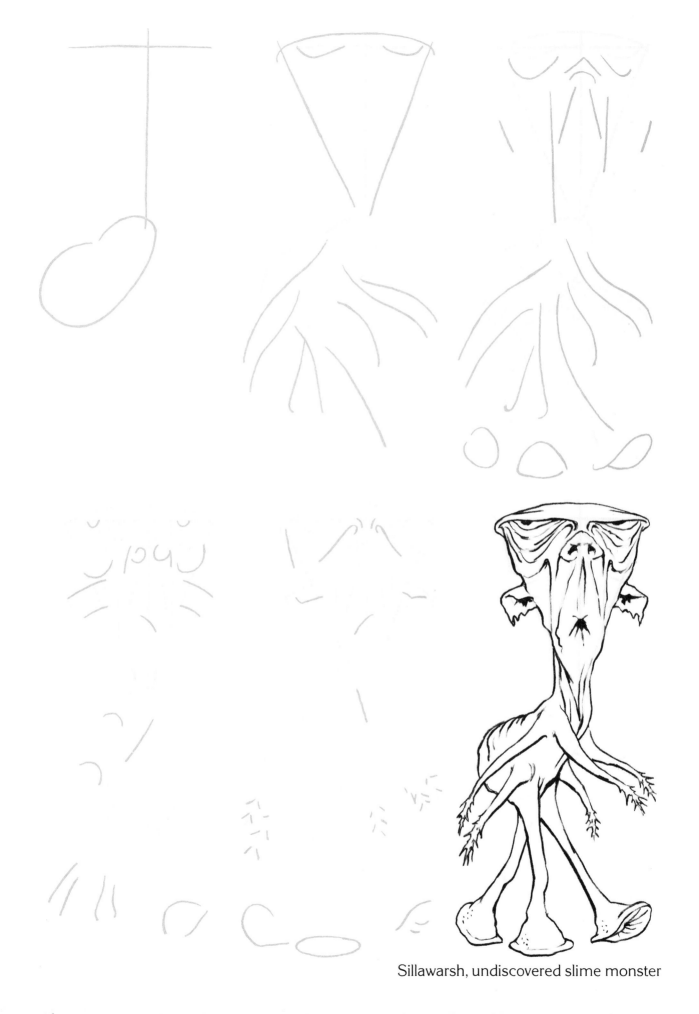

Sillawarsh, undiscovered slime monster

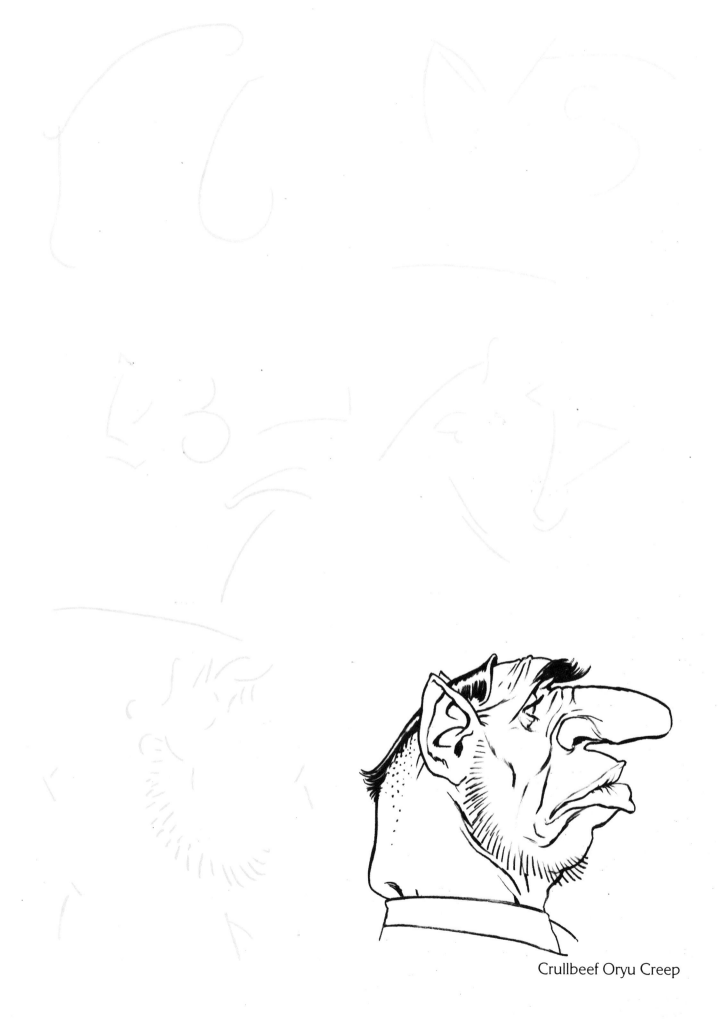

Crullbeef Oryu Creep

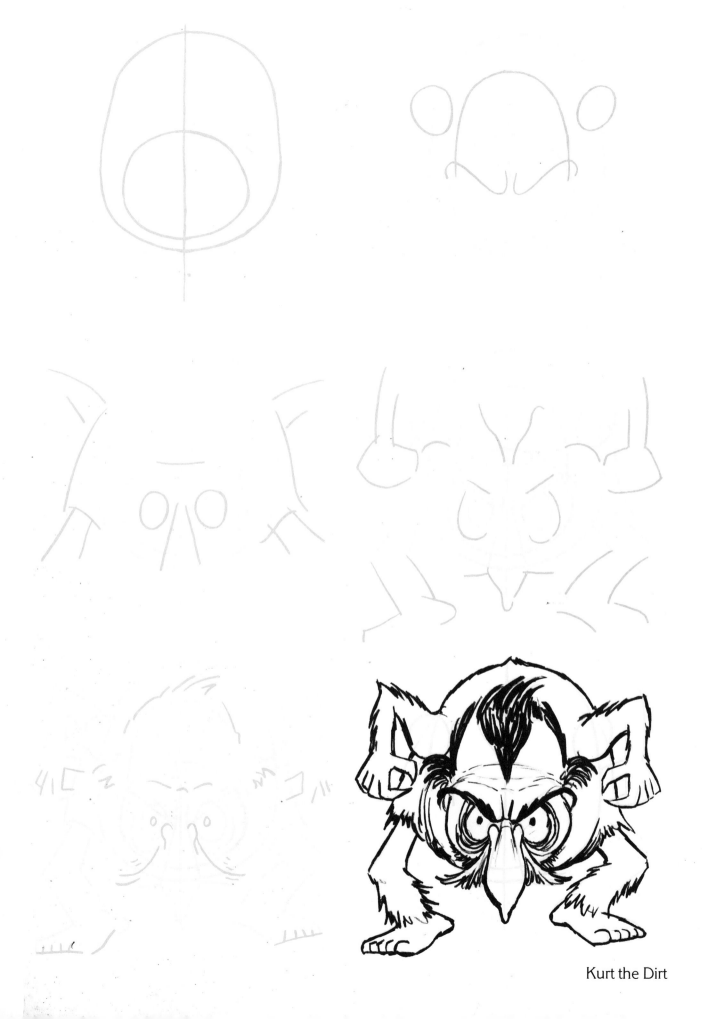

Kurt the Dirt

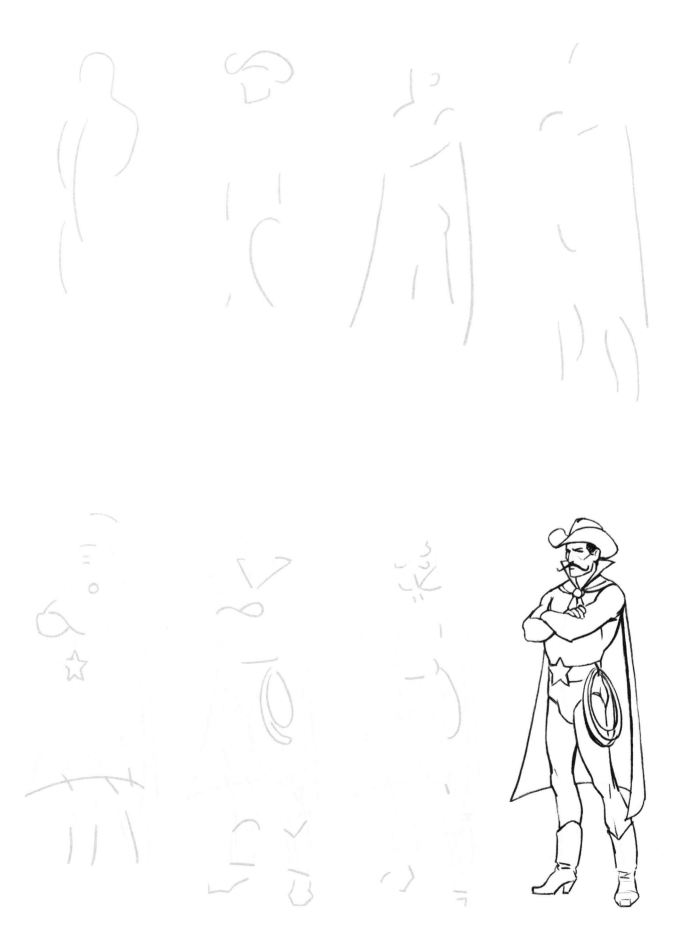

Super Cowboy

Lee J. Ames began his career at the Walt Disney Studios, working on films that included *Fantasia* and *Pinocchio*. He taught at the School of Visual Arts in Manhattan, and at Dowling College on Long Island, New York. An avid worker, Ames directed his own advertising agency, illustrated for several magazines, and illustrated approximately 150 books that range from picture books to postgraduate texts. He resided in Dix Hills, Long Island, with his wife, Jocelyn, until his death in June 2011.

DRAW 50 MONSTERS

Experience All That the Draw 50 Series Has to Offer!

With this proven, step-by-step method, Lee J. Ames has taught millions how to draw everything from amphibians to automobiles. Now it's your turn! Pick up the pencil, get out some paper, and learn how to draw everything under the sun with the Draw 50 series.

Also Available:

- *Draw 50 Animal 'Toons*
- *Draw 50 Animals*
- *Draw 50 Athletes*
- *Draw 50 Baby Animals*
- *Draw 50 Cars, Trucks, and Motorcycles*
- *Draw 50 Cats*
- *Draw 50 Dinosaurs and Other Prehistoric Animals*
- *Draw 50 Dogs*
- *Draw 50 Famous Cartoons*
- *Draw 50 Flowers, Trees, and Other Plants*
- *Draw 50 Horses*
- *Draw 50 People*
- *Draw 50 Princesses*
- *Draw 50 Sharks, Whales, and Other Sea Creatures*
- *Draw 50 Vehicles*
- *Draw the Draw 50 Way*